# Cast Drawing Using the Sight-Size Approach

# Cast Drawing
## Using the Sight-Size Approach

Darren R Rousar

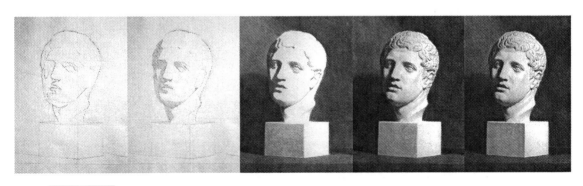

⌂ The Sight-Size Library™

Velatura Press LLC, Publisher                    Minneapolis, Minnesota USA

**Cast Drawing Using the Sight-Size Approach** by Darren R Rousar

First published in 2007 by
**Velatura Press LLC**
5575 Shorewood Lane
Minneapolis, Minnesota 55331 USA
*www.velaturapress.com*     *www.Sight-Size.com*

ISBN-13: 978-0-9800454-0-6
First Printing, 2007
Printed in the United States of America

Library of Congress Cataloging-in-Publication Data

Rousar, Darren R.
  Cast Drawing Using the Sight-Size Approach / by Darren R Rousar.
  Includes bibliographical references and index.
  ISBN-13: 978-0-9800454-0-6
  ART010000   ART / Techniques / Drawing

Library of Congress Control Number:  2007938841

For more information about other books in the Sight-Size Library™ as well as instructional DVD's and Sight-Size in general please direct your web browser to www.Sight-Size.com.

 *Velatura Press*™ Minneapolis, Minnesota USA

*For my wife Kathleen.*
*Besides being a gifted artist in your own right, you are my best friend.*
*I love you.*

# ·Table Of Contents·

# ·Acknowledgements·

*"Don't bother just to be better than your contemporaries or predecessors. Try to be better than yourself."*                    -William Faulkner

Many people are behind the creation of a book. In my case, the group begins with my family. No artist ever had a more supportive family. Dad, Mom, Eric, Sarah and Anne, thanks for always being there.

To Ginto Naujokas and Annette LeSueur. Each of you saw qualities in me that I didn't and both of you helped lead me down the various paths to my present.

Pat and Jeff Jerde have been friends for almost longer than I can remember. Pat, you were the first person to show me that I could teach and in a way, you were my first student. Thank you both for many of the opportunities that came my way.

Thank you Claire Commers for helping me to keep things on a positive note.

And finally, to Charles H. Cecil. I learned more from you than my skills might show. You have been my teacher, my mentor and a friend. I hope this book accurately carries on the tradition.

# ·Preface·

*"Art, as far as it is able, follows nature, as a pupil imitates his master; thus your art must be, as it were, God's grandchild."*     -Dante Alighieri, Inferno

I have been teaching the Sight-Size approach to drawing and painting for 20 years and over that time I have noticed a few concepts that students find hard to grasp. Part of the difficulty is that drawing and painting are visual while teaching is usually verbal. How does the teacher get the student to visually see in the same way that he or she does?

With the drop in the costs of quality video equipment the idea of producing a DVD on the Sight-Size approach became a reality for me in late 2006. If I could put the camera lens where my eye was while doing the drawing or painting, my students could see a version of what I was seeing and possibly understand a little better. While writing the scripts for the DVD, *Sight-Size and the Art of Seeing,* I soon realized that I had the makings of a book and therefore, another way to teach my students.

This book is merely the first in a number of instructional books and reprints of rare texts that directly or indirectly relate to the Sight-Size approach.

Welcome to The Sight-Size Library.™
    -Darren R Rousar  October 1, 2007

The traditional Sight-Size setup as viewed from the side.

A     The artist in the viewing position
B     Cast or still life stand
C     The cast
D     Light source with light direction
E     Easel and drawing board/paper

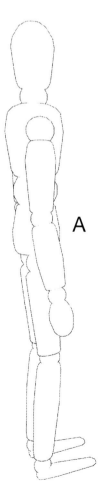

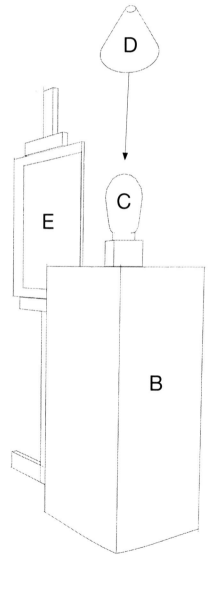

Figure 1, Side View

# ·Introduction·

*"I don't believe in total freedom for the artist. Left on his own, free to do anything he likes, the artist ends up doing nothing at all."*     -Federico Fellini

Today's artistic culture is often driven by feeling and shock. Some have railed against this while others embrace it. I do not intend to take up too much of that argument with this book. However, my belief is that to have artistic integrity you must do something by choice rather than out of ignorance. True artists, like musicians, do not just spring from the earth fully formed. They must learn a system, method or approach and practice what they have learned. Luck, ignorance or whim do not make good, lasting art. When it is discovered that the emperor has no clothes, everyone loses, the artist and the public. Now you know my bias, as if the subject of this book was not enough of a clue.

You must also know what you are learning. Art, as we now have it, is amorphous. Even in today's realist circles there are different movements. To be clear, this book presents a specific and traditional way of looking at nature as well as recording what you see. In fact, it is much more about seeing than drawing. In the end, it is only when one learns how to see accurately can one truly draw.

Notice that I will try to use the word *approach* rather than *method* when discussing Sight-Size, the subject of this book. This is intentional even though both words are synonymous. My opinion however is that a method is more of a list of actions that lead to a goal whereas an approach is broader than that. An approach forms and directs the method. Therefore, Sight-Size as an approach is more than a set of instructions to follow, it is a principle or concept that goes beyond mere measuring.

## Naturalistic Seeing

The basis of the approach presented here is not an *ism*. It is a way of seeing that some *isms* flowed out of. The Realists, Naturalists and the Impressionists tried to represent nature as they saw it. They just did so with different eyes, figuratively speaking. Prior to those movements there was Titian and later, Velazquez. Many of those artist's works show a careful observation of nature. It is in their light that I speak of *naturalistic seeing* and that is the ultimate goal of the Sight-Size approach.

Seeing naturalistically and drawing or painting what you are seeing is difficult unless one condition is met. That condition is a combination of the placement of your drawing or canvas relative to the subject and your viewing position relative to both. Properly understood, this combination allows the artist to accurately compare the work with nature in one glance. The eye does not have to refocus nor does the mind have to transpose different sizes.

## To Draw What You Know or What You See?

There are essentially two ways of drawing. One relies upon what you know (or think you know). This way

was initially developed from a system of comparative proportion codified by the ancient Greeks. Later, mathematical formulas and actual observation enlightened artists about the rules of perspective. This combination of comparative proportion and perspective has produced a number of the world's great masterpieces. It also produces illustration. Many commercial and fine arts colleges teach variations of this combination, even while the student is looking at a live model. But if the goal is fidelity to nature, would it not be better to actually observe nature and portray what you are looking at, deviating only when it helps you achieve your goals for the work?

This brings us to the second way of drawing, which is drawing what you see. Drawing what you see means that, for a time, you try to forget that you know certain things about the world. An average male might be a given number of heads tall but what about your particular model? Of course this is overly simplistic but it does make the point that nature, while based upon a set of rules or patterns, has a great many deviations from the norm. These deviations are why you look different from me and from everyone else. Observing and recording deviations more subtle than that can help the drawing or painting look real to the viewer.

The act of drawing what you see can be further subdivided into two approaches. One is to sit with the drawing board in your lap and the model in the distance. This way of drawing is also quite common in today's art schools. Yes, you are looking at the model and you may or may not be comparing proportions. The difficulty with this way of drawing is that your eye cannot take in both the drawing and the subject in one glance. Whether you are aware of it or not, you

must constantly refocus as you look between the two. To add to the difficulty, the drawing will most likely be a different size than the model. This compounds the problem as you now have to mentally transpose the size of the model to the size of the drawing. All in all there is a chance of creating an accurate drawing using this method, but the job is more difficult than it has to be.

The other approach to drawing what you see is called Sight-Size. Essentially, the Sight-Size approach is drawing or painting your subject in the size you see it, from a specific distance. This approach is all about comparing your work to nature (your subject). To compare the two successfully, the work must be placed right next to the subject. Then, both the work and the subject are viewed from a distance that is far enough away to see both in one glance without having to turn your head or refocus your eyes. Figuratively speaking, all of your drawing takes place from that distance. More to the point, all of your seeing takes place from that distance. You then walk forward, place your mark and walk back to compare. This process is repeated over and over again.

While the Sight-Size approach does not have to mean life size, it is often done that way. To draw life size you must place your easel physically next to the subject. You then stand back far enough to view both without having to turn your head while looking straight on. *-Please refer to the diagrams at the beginning and end of this chapter for a visual explanation.*

How far back does one stand? It depends on a couple of things which I will discuss later. The general principle though is nicely summed up by Leonardo da Vinci.

*"When you draw from nature, stand three times as far away as the object you are drawing."* Therefore, the greatest length of the scene (either width or height) must be multiplied by three in order to find the proper viewing distance. This distance is the minimum that one would need to stand back in order to focus on both the work and the scene at once. So, for the average cast drawing, the artist would need to stand back from the setup somewhere between 6 and 8 feet.

To draw smaller than life size you would *visually* place the easel next to the subject but *physically* it would be closer to you than the subject. In this way you would still view the drawing and subject at once but the distance you would need to travel to get to the easel would be less. Pencil figure drawing in most ateliers is done this way. In fact, most often the easel is directly in front of the student and no traveling is required.

To draw larger than life one does the opposite. That is, place the easel farther away from you than the subject, while viewing both from the chosen position.

The Sight-Size approach can solve every problem associated with the other methods. Of course that somewhat depends upon the artist, but at least in this way the artist does not have to overcome the problems inherent in the method.

*"Know that a painted thing can never appear truthful where there is not a definite distance for seeing it."*
-Leon Battista Alberti

## Sight-Size - A Short History
There is historical, written evidence for the use of Sight-Size. A friend of mine, Nicholas Beer of Salisbury,

England, has researched this subject at length. As of this writing, Nick has an essay accessible on Charles Cecil Studios' web site (www.charlescecilstudios.com). In addition, there is a link to the essay on www.Sight-Size.com. His essay presents a compelling argument for the history of Sight-Size and my hope is that everyone will read it. Rather than rewrite what Nick has so admirably written, I will present two quotes that hopefully prove the point.

Initially, Sight-Size was a portrait painting technique. Sir Henry Raeburn was a brilliant, eighteenth century Scottish portrait painter. In describing a painting session, one of his sitters said, *"… and then having placed me in a chair on a platform at the end of his painting-room, in the posture required, he set up his easel beside me with a canvas ready to receive the colour. When he saw all was right, he took his palette and his brush, retreated back step by step, with his face toward me, till he was nigh the other end of the room; he stood and studied for a minute more, then came up to the canvas, and, without looking at me, wrought upon it with colour for some time. Having done this he retreated in the same manner, studied my looks at that distance for about another minute, then came hastily up to the canvas and painted a few minutes more."* [1]

During the late nineteenth and early twentieth centuries, John Singer Sargent was America's greatest portrait painter. A fellow student with Sargent in Carolus-Duran's atelier was William Rothenstein. In his memoirs he wrote, *"Sargent, when he painted the size of life, placed his canvas on a level with the model, walked back until canvas and sitter were equal before his eye, and was thus able to estimate the construction and values of his representation …"* [2]

I believe that anyone who can see can learn Sight-Size. Even those who think that they have no talent. I have taught Sight-Size to all ages from 7 to 85 (naturally the younger ones are taught a modified version of the approach) and everyone ends up with something beyond their expectations.

## Cast Drawing

The traditional way to learn Sight-Size is through cast drawing. Cast drawing for a naturalistic, Sight-Size painter can be compared to scales for a pianist. Both activities are a means to an end. When learned well, the training will eventually become habit and a part of the artist's subconscious. That is when the art comes in. When the artist is no longer thinking about the mechanics of what they are doing, only then are they truly free to express themselves through their art. Deviation from nature becomes an artistic choice and not an accident.

*"Why can't I just sit there with my drawing pad and sketch it?"* That was the first question one of my students asked me a few years ago. My response was that of course he could. Artists have done that for millennia. Even I do that on occasion. However, as students we sort of start out blind. I as the teacher have the eye. That eye, or way of seeing has been passed down to me from master to pupil from centuries back. In order for me to give you that eye there are a few stipulations. One is that both of us are able to see the same thing from the same position. The other is that the set up (the easel, the object and artist) never changes position. The advantage of this for the teacher is great as the student has no excuses for errors in the drawing. The teacher can see what the student is seeing. The ultimate advantage though is to the student. Being

corrected time after time in shape, value and edge is what eventually causes the student to see like the master. That eye I was talking about will have been passed down again.

This is not to say that sketching is a bad thing. Quite the contrary, but the goals are different. I believe that sketching should not even be taught. At the schools where I have studied or taught, we always had evening open studio sketch times from the live model. Yes, I and other teachers might show up but that was to participate, not critique. The students were allowed to draw or paint as they pleased without the strictures of the formal studio setting. Sketching allows the student to practice methods that the real world might force upon them when drawing something using Sight-Size would be impractical.

The reader should understand that Sight-Size is one approach to drawing and painting but it is not the only way. I and others believe it is the best way but the proof is in the result. In the end, how you get there is less important than getting there in the first place.

1    Allan Cunningham, Lives of the Most Eminent British Painters, Vol. II., 1831

2    William Rothenstein, Men and Memories, Coward McCann, 1931

Figures 2 and 3 (facing page), the traditional Sight-Size setup as viewed from the top and front.

| | |
|---|---|
| A | The artist in the viewing position |
| B | Cast or still life stand |
| C | The cast |
| D | Light source with light direction |
| E | Easel and drawing board/paper |

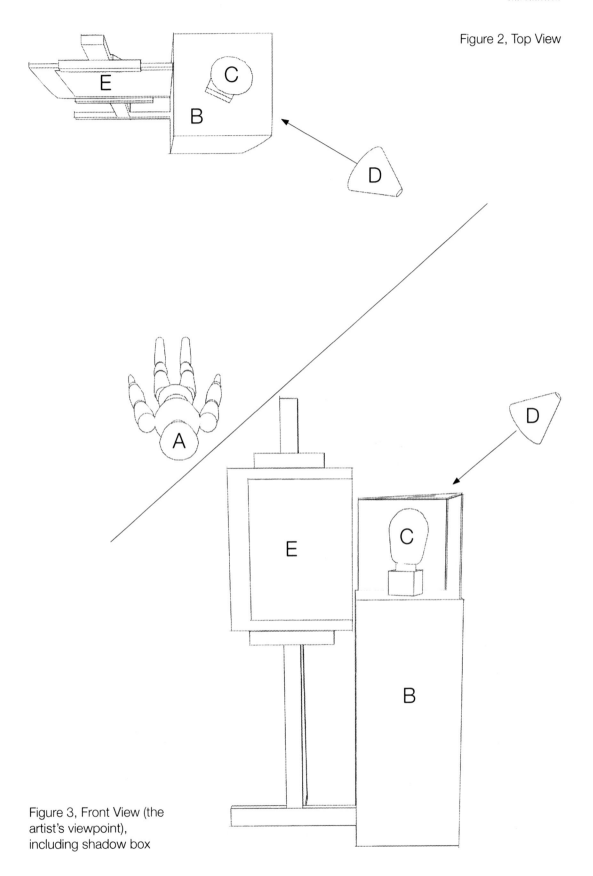

Figure 2, Top View

Figure 3, Front View (the
artist's viewpoint),
including shadow box

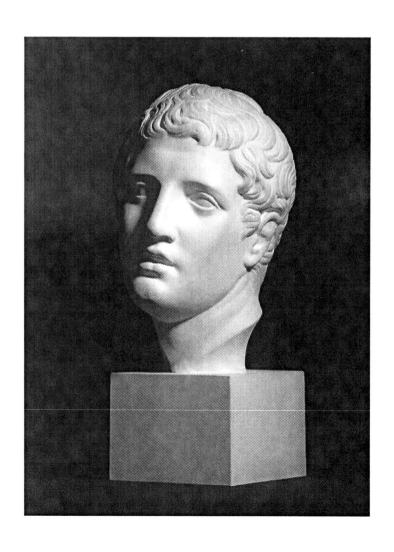

# ·Setup & Materials·

*"Lying in bed would be an altogether perfect and supreme experience if only one had a colored pencil long enough to draw on the ceiling."*      -G.K. Chesterton

As mentioned in the introduction, Sight-Size drawing has a few requirements. The most important are the placement of your subject, your easel and yourself. To that end, Sight-Size cast drawing is usually done in life size.

## The Studio

As a student, you need a room where you can control the lighting and the space. The ideal would be a room that is at least 12 feet long and 10 feet wide with a 9 foot ceiling. Not a common room in the States to be sure. The principle though is this, the room has to be long enough for you to stand back and high enough for your light source to be above your setup. Outside of either a purpose built space or a functioning atelier* the ideal may have to wait. To make due, use what you have. As long as you can stand back at least 8 feet from the setup and the ceiling is 8 feet high it will work for a cast drawing.

Facing page:
The demonstration cast, Bust of the Discobolus

*An atelier (pronounced, *atel-yay*) is a studio school.

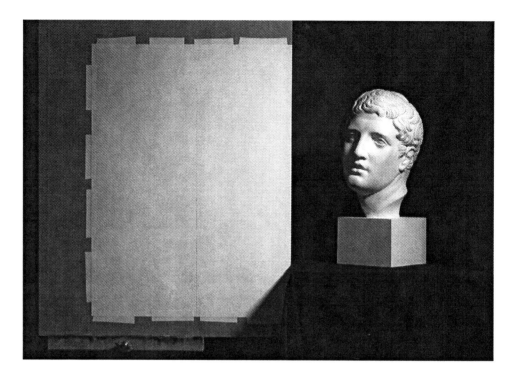

The main cast setup showing the paper properly taped to the drawing board

## The Cast

For a subject you will need a plaster cast that is white or off white (darker tones will not work). These are readily available from a number of sources (see the appendix and/or www.Sight-Size.com for a list of suppliers). Masks, which hang on the wall and casts on pedestals are equally good. Heads, body parts, animals and botanicals are all useful but I usually have my students use heads. Prices can range from $20 to hundreds of dollars depending on the quality of the cast. A $20 cast will teach you just as much as a $500 one so don't fret. Buy what you can afford.

## The Stand

The cast should be placed at about eye level. Some prefer it a bit below eye level but I prefer it a little above. In a pinch, a tall filing cabinet or a set of book shelves could work. Also, many art supply stores sell sculpture stands that are high enough to work. Traditionally though, one makes a special stand.

If you are using a freestanding cast, you will also need a shadow box. This is a three-sided box that helps control the light that hits the cast. Once built, it should be painted a flat, dark grey or black. Turned around, the shadow box could also be used to hang a hanging cast on.

## The Easel

Next comes an easel. Whatever style you purchase, you need to make sure of a few things.

-The easel must be able to hold the drawing board perfectly vertical, straight up and down.

-The easel must be able to hold the drawing board high enough that the center of the drawing board can be at eye level.

-You will be placing the easel (actually the plane of the drawing board) midway between the front and the back of the cast. Your studio may not be long enough for the back leg of the easel to project back very far when everything is in position. Measure your space first and buy once.

The viewing position

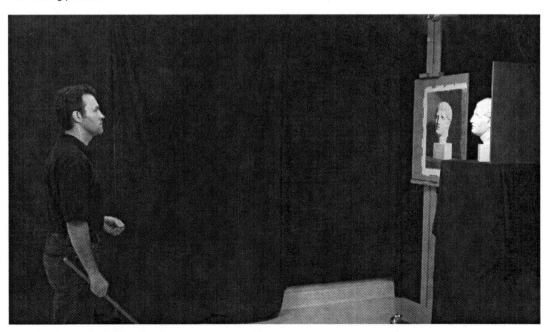

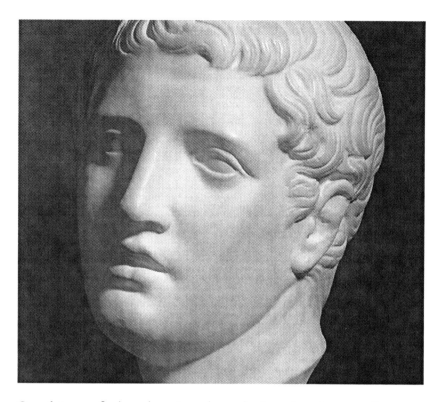

Light and shade pattern showing triangle of light on the cheek

Speaking of the drawing board, its size is usually determined by the paper you use. Often that's about 20″ × 25″. I tend to have my students get some ¼″ smooth hardboard cut at the local hardware chain outlet but art stores do carry drawing boards. Beware of the ones with metal clips to hold the paper and holes for handles. I find both aspects to be one kind of hassle or another.

## Placement

Place the shadow box on the stand and the cast in the shadow box. Then place the easel directly next to your cast stand and the drawing board on the easel, making sure that plane of the drawing board is midway between the front and the back of the cast. Right-handers normally have the easel on the right side of the cast with the light on the left side of the cast, whereas left-handers do the opposite. This is so your drawing hand does not cast a shadow on the area

of your paper where you are trying to draw. In the ateliers you often are not given a choice in the matter. It is nice to do but it is not extremely important.

## Lighting

Most naturalistic artists prefer natural light and I am no exception. If you have the type of make due room described above, the top of the window most likely ends at 7 feet off the ground. With the light that low, only a raking light is possible on the cast. Instead, use a clamp, spot light with a 75 to 100 watt bulb (be sure to check the wattage specifications on the lamp). Many ateliers use this type of lighting for their beginning cast work. This gives you the ability to put the light right up near the ceiling and direct it down on your setup. The light should be 3 to 4 feet above, over the same distance to one side as well as being in front of the setup. You want to have a somewhat even light on both the cast and the drawing board. Block out any windows in the room to eliminate reflected light (more on that later). Once you are past the student stage you can contend with multiple light sources.

Turn the cast a little until you have a nice pattern of light and shade. It is traditional to have the cast turned away from the light by about three quarters so that one quarter is in shadow. It is also quite common to have a little triangle of light on the cheek on the shadow side of the head.

## Viewing Position

Finally, find where you will be standing. For the normally sized cast (anything less than 2 feet high) a good viewing position would be about 8 feet directly back from the setup. 6 feet would do if necessary. Beyond the viewing position, having the space to

stand back 12 feet from the cast would give you the most options. Laterally, you will want to stand on an imaginary line that runs between the cast and the easel. Place a strip of tape on the floor at that spot so you know where to walk back to. Eventually you will get used to the pacing and naturally back up the correct distance.

If for some reason you do not have total control of the room, try to tape off the placements of the easel, stand, lighting and cast. Every time something is moved it makes your job harder to do. That is the beauty of cast drawing compared to portraiture. With a portrait, the model is moving all the time. The cast is, or should be, consistent and stationary. If at all possible, I would not however, recommend moving the cast between sessions. It will be very difficult for the student to replace the cast back in the same position.

## Materials

In addition to the studio space, cast, shadow box, stand, drawing board and easel, you will need drawing materials. The standard list follows and I have listed US and some European suppliers in the appendix as well as on Sight-Size.com.

**Paper-** For the beginner, white is the rule. Leave the toned paper for your second (or fifth) cast drawing. In the US, Canson-Ingres is the usual choice although Strathmore makes a usable, smooth charcoal paper. In Italy, we tended to use Fabriano Roma which is slightly off yellow. Since it is hand made, it has a rougher texture than the others and therefore it affects your final finish. Plus, it can cost up to $20 per sheet in the States whereas the others might be less than $2. Generally speaking you want a smoother paper for a beginning cast drawing. Buy a few sheets and tape one

to your drawing board. If you can feel or see a smooth side, make that side face up. Tape the paper flush to the side of the board that the cast is on. Do not put tape on that side however. See the image on page 24.

**Charcoal-** The brand Fusain Nitram is the usual recommendation for charcoal. While it works well, it is both expensive and hard to find. Perhaps I am a rebel but I much prefer Windsor & Newton. Whichever brand you choose, make sure you are buying what is known as vine charcoal. Do not buy compressed charcoal, at least until you have done a cast or two and understand how your charcoal works. You will need quite a few of all harnesses (soft, medium and hard).

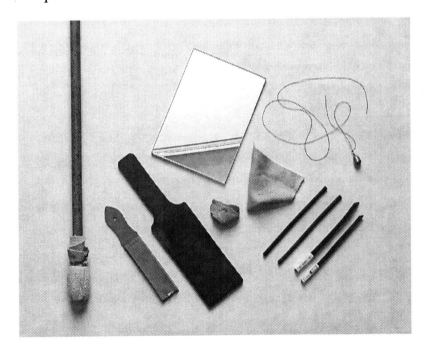

Materials,
counter clockwise from left:
Mahl stick, sharpening blocks, kneaded eraser, chamois, charcoal sticks, plumb line, hand mirror

**Chamois and Kneaded Eraser-** Both erase the charcoal. The chamois is for the larger areas and the kneaded is for the details. While a chamois is commonly used to wash cars, it is best to buy a new one, or at least thoroughly rinse and dry the used one. You will need a 4 inch square of chamois and a kneaded eraser or two.

**Sharpening Block-** This is used to sharpen the charcoal to a point. Many art supply stores carry these. You can also make your own with some glue, a small block of wood and some fine or extra fine sandpaper. Remember that we draw with a point, not a blunt edged stick.

**Hand Mirror-** This is the best tool to check your work, even when you have a teacher. In fact, you will use this the rest of your life. Get one that is about 4″ × 6″ and that has no colored plastic around the edges. Make sure the edges are smooth.

**Plumb Line-** This is simply a 3 foot length of dark, heavy thread with a small weight tied to one end. I use a fishing sinker for my students but a hardware nut would work just as well. This is your primary measuring tool.

**Mahl Stick-** Pronounced 'maul-stick,' this is 3 foot length of ½″ dowel. You will use this as sort of a bridge to protect your work surface from your hand. Usually one wraps a piece of chamois around one end to protect the paper in case it gets hit with the end.

**Artist's Tape-** This is for you to tape your paper to your drawing board. Artist's tape is easily removable.

**Spray Fixative-** When you complete your cast drawing you will need to protect it. Framing it is a good choice but even then some of the charcoal can fall off. Be sure to follow the instructions on the can.

**Black Mirror-** Commonly used in ateliers, this mirror reflects in a way similar to looking through sunglasses. It dulls and simplifies the values down a little. I do

not find it that useful in my own work but, as I said before, it is widely used in many of today's ateliers. It is in reality a reflective piece of black Plexiglas.

**Knitting Needle, wooden skewer, etc.-** Some ateliers use these to help the student measure. I do not use them but that should not invalidate their use.

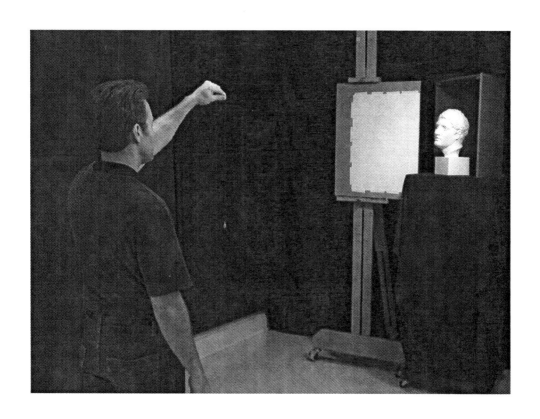

# ·Beginnings & Blocking In·

*"The art of seeing Nature... is in reality the great object, the point to which all our studies are devoted."*                    -Sir Joshua Reynolds, Discourse XII

To begin, we need to make sure that the drawing board is straight up and down, both side to side and front to back. You can use a carpenter's level for this or your plumb line.

## Sharpening

The next step is to sharpen your charcoal. Use the soft charcoal and sharpen a few of them. This is a routine you will be doing many times a day. When you draw with a blunt end you do not really know exactly where the charcoal is touching the paper. Being off as much as ⅛ of an inch is enough to lose a likeness. Throughout the drawing, when your charcoal gets dull, sharpen it. To sharpen the charcoal, hold the charcoal stick at a shallow angle (about 15°) and sand it back on forth over the sanding block. While sanding, slowly roll or twist the stick back and forth.

Facing page: Checking plumb with the plumb line (hanging from my left hand but barely visible in the photo against the black background)

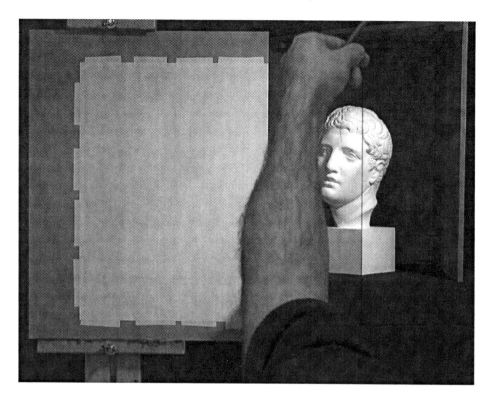

## Verticals

Sharpening is just a prelude. The real beginning is finding the main vertical line. Some call this a center line but it does not actually have to be in the center. It is simply an invented line that visibly crosses at least two points on the cast. This line helps you position the image of the cast on your paper and gives you a starting point.

Take your plumb line and stand back in your viewing position. Hold the plumb line out in one hand and straighten your arm. Close one eye. Visually place the plumb line over the cast. Once the plumb line stops moving, slowly move your arm left and right until it crosses more than one obvious point on the cast. It is better if these points are close to the center of the cast but any two points, one above the other, will do. This will be your main vertical line and it is the line that the whole cast will be drawn off of. Next,

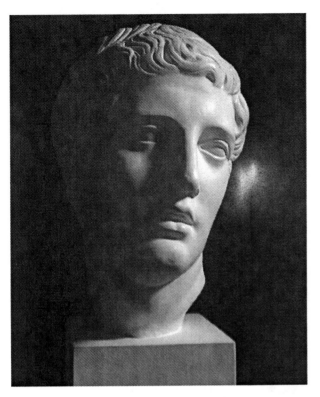

View from the drawing board

walk up to your drawing board and use a soft charcoal and yard stick to draw a straight, vertical line in the center of the paper. Draw very gently as you will eventually need to be able to erase this line. Stand back in your viewing position, close the same eye as before and hold up your plumb line. This time, visually place the plumb line over the charcoal line that you drew on the paper to check your vertical. If your charcoal line is not straight, erase it with your chamois and redraw it.

## Closing One Eye

Why do we close one eye? When looking through both eyes, we see in stereo and that is what allows us to perceive depth. While the world we see is three dimensional, the paper is flat or two dimensional. The artist's ability to fool the viewer into believing that the drawing is three dimensional must be found elsewhere. Value and edge are the main tools for this but there is another help and that is to close one eye. When you close one eye, you see the world flat. We must see flat to draw round. Which eye you close is irrelevant. What is relevant is that you consistently close the same eye every time.

## Repeat After Me...

Over the course of this book I will repeat a few things over and over again, like suggesting you close one eye. In fact, I could almost insert these things at the start of every paragraph. Repetition is how we learn.

1- Always view the cast from the viewing position. This means NEVER stand at the drawing board and sneak a peak at the cast. This is not the position you are drawing it from and therefore you will be seeing the cast at a different angle.

2- Always close one eye when looking at the cast.

3- Do not go too dark with your lines. You may need to erase them before the drawing is finished.

## The Big Look

Now is the time we can start blocking in the main shape of the cast. One hundred years ago, blocking in meant roughly sketching in the subject, as in a gesture drawing. Today, blocking in means defining the perimeters and main shapes. Sometimes this is also known as laying-in but this term is most often applied to the initial stages of a painting.

In this stage we are trying to define the large, general shapes that make up the cast. This is part of what is called the big look. Don't worry too much about the smaller, complicated shapes but try to think in terms of large puzzle pieces. What parts of the contour can you simplify and still be able to recognize the cast? This big look is what you see from a distance. The farther you move back from something, the fewer details you see. As an example, we can recognize someone we know from a great distance, long before we can make out details like the color of their eyes. The big look is where the basis for likeness resides.

## The Top and Bottom

To begin, we need to find the top and bottom of the cast. Grab a soft, sharpened charcoal stick, your plumb line and chamois. Stand back in your viewing position, close one eye and hold the plumb line out

Finding the top of the cast

with both hands. Be sure to lock your elbows and try to keep both arms equally raised. It is common for right-handers to hold their right arm a little higher and left-handers the opposite. You will slowly correct this as time goes on but one solution I have found is to begin by visually placing the plumb line on the top of the drawing board when you first raise your arms. Then slowly, and equally, lower your arms until the line visually touches the top of the cast. Hold steady and run your eye across the line until you reach the vertical line you drew on the paper. Keep your eye on that spot and walk forward to the spot. Put a slight mark there and back up to your viewing position. Repeat the process to check your mark.

Once you are pleased with the position of the top of the cast, find the bottom of the cast using the same procedure. While you are at it you might as well find any number of obvious points like the height of the nose, mouth, eyes, etc. Remember, at the moment we are only interested in finding the boundaries.

## Widths

The next step is to find some of the widths of the cast. Back in your position with the charcoal, plumb line and chamois, close one eye and again hold your arms out. This time hold the line with your hands close enough together to measure with your thumbs. This is done by visually placing your right thumb on one of those points you found for the main vertical line and the left thumb on the other side of the cast. Once you find that, move your arms over to the drawing and, without moving your thumbs, visually place your right thumb on the vertical line. Look past your left thumb over to the paper. Fix your eye on it and walk straight to that spot. Place your mark, back up and check yourself. Do the opposite for the right side of the cast. Once you are happy with the placements, use your thumbs and the plumb line to check the complete width of the cast. This procedure is a way to double check your marks.

Transferring the width to the paper

Continue to do as described above, up and down the cast, for any number of obvious points. Some students spend days working on this step while others a few minutes. It is up to you but remember that you are just giving yourself some of the boundaries within which you will do the drawing. When finished, connect the dots. At this point, I tend to draw flat lines, or facets, between the marks but some prefer to follow the curves they are seeing a little more closely.

## Mistakes Happen

Throughout this process mistakes are important in that they help you determine where the proper mark should be placed. A needle in a haystack is hard to find but it is easier to find if you know that it is one inch away from a known spot.

## Contour, Outline, Arabesque

Correctly delineating the outline or contour is of upmost importance and you must make a concentrated effort to draw this line accurately. When you are fairly confident in the basic shape, go back over the line and correct the *flats* or *facets* into their proper curves. This correcting will also help you see where your basic lines are off. Once again, try to draw this line as correctly as you can before moving on with the drawing.

All this work with the plumb line can become a little constricting, but remember, you are a student learning your scales. Once your eye is trained you will most likely dispense with some of the mechanics. As an example, other than for student demonstration purposes, I can't remember the last time I used a plumb line. For measuring I use the charcoal itself or the paint brush whereas others might use a knitting needle.

## Linear Conventions

When drawing, one must remember that there are few actual lines in nature. The majority of what we see is made up of overlapping shapes and connected values. This means that drawing and outlining are at least one extra step removed from nature. Even though we are using a sharp charcoal, our end result will be a value or mass drawing and not a line drawing. As such, the outline we just drew is merely a boundary for values and the edge of a physical shape. Line drawing can also be done Sight-Size and is most often done using a pencil.

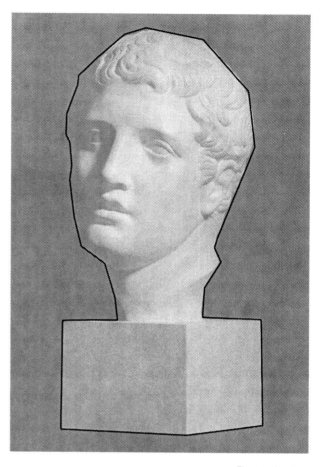

Flats or facets

With all of the focus on the outline I want to make it clear that I believe that a proper outline cannot exist without a reference to the interior of the shape. Outline is of prime importance and the student should spend considerable time and effort in achieving an accurate contour, but at some point the outline has

The bed-bug line

to be seen as part of the whole. One of the reasons for that is the shapes of things in the interior of the cast can help you see the contour better.

## The Bed-Bug Line

Once you have drawn the contour accurately it is time to move on to the interior. This does not necessarily mean that I want you to specifically start drawing the eyes, nose and mouth. Remember the big look? At the moment, ignore whatever you are seeing within the shadowed areas and concentrate on the main shadow line. Some know this as the bed-bug line and that is what I was taught. This line separates light from shade and is very important. When you are finished with the drawing, how you handled this line will in great measure determine how much depth the viewer thinks they are seeing. For now, take pains to place this line properly. Also keep in mind that this line has to correctly relate to the contour as well. Remember to always compare.

Within the cast there will most likely be islands of shadow and light. Draw these in but try to keep them simple. Try not to think about the actual features you are drawing. Try to only think about shapes of light and dark that just happen to form a facial feature. In addition to plumb line measurements and comparing the shapes you are drawing, compare the placement of one shape to another shape. For instance, how far

away is this part of this shape from that part of that shape? Of course one could name the features here but I am trying to make a point by being consistent. Naturalistic seeing is always comparing.

## Triangulation

Another way to measure, and this is the way I draw and paint, is to use triangulation. One of the definitions for triangulation in the American Heritage Dictionary is: *The location of an unknown point...*

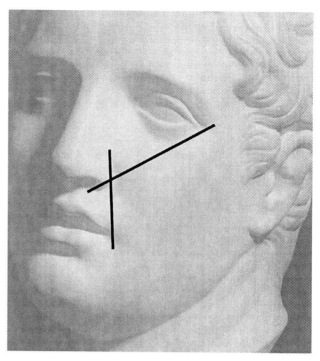

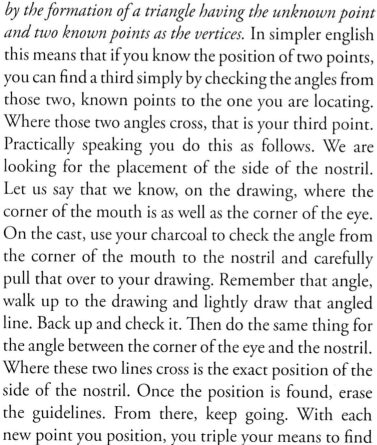

Triangulation

*by the formation of a triangle having the unknown point and two known points as the vertices.* In simpler english this means that if you know the position of two points, you can find a third simply by checking the angles from those two, known points to the one you are locating. Where those two angles cross, that is your third point. Practically speaking you do this as follows. We are looking for the placement of the side of the nostril. Let us say that we know, on the drawing, where the corner of the mouth is as well as the corner of the eye. On the cast, use your charcoal to check the angle from the corner of the mouth to the nostril and carefully pull that over to your drawing. Remember that angle, walk up to the drawing and lightly draw that angled line. Back up and check it. Then do the same thing for the angle between the corner of the eye and the nostril. Where these two lines cross is the exact position of the side of the nostril. Once the position is found, erase the guidelines. From there, keep going. With each new point you position, you triple your means to find

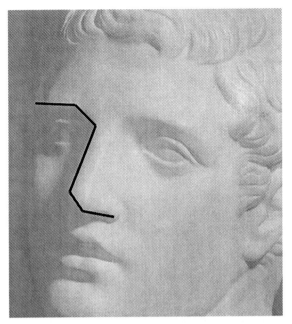

The van Dyck Z

an additional point. The whole drawing can be blocked in this way. This concept will greatly speed up your drawing and eventually let you dispense with the plumb line. It also makes your drawing more accurate because it relies on comparing two parts of the image to find a third. Therefore, each shape is related to every other shape. Make very sure you follow this concept as it is a major revelation.

## The van Dyck Z

Closely related to triangulation is something called the van Dyck Z. The van Dyck Z is simply the angles and lengths of the continuous edge of the eyebrow, the long side of the nose and the base of the nose. Depending on the setup, this *Z*

Checking angles

The block-in

may look more like an *S*. Either way, establishing the relationships between these lengths and between these angles can take you very close to achieving an accurate likeness in the drawing.

## More Angles

To sum up, between triangulation and the van Dyck Z there is a common theme. This theme is angles. Angles help you draw in a way that compares one part of the cast to another. A word of caution however. Do not use your plumb line to check angles. Remember how hard it is to hold the line perfectly horizontal? It is harder to maintain a consistent angle when moving your arms between the cast and the drawing.

## Negative Shapes

A large part of drawing is a mental game of what you think about when you are seeing. One thing to think about are negative shapes. Imagine a stairway. The balusters (vertical supports that hold up the railing)

themselves are positive shapes and these are the kinds of shapes we usually think about when we draw. The spaces between the balusters have a shape as well and these are called negative shapes. It is really the opposite side of the coin. On the cast, the negative shape is the shape of the background where it touches the cast. Thinking about the negative shape (in addition to the positive shape) will help you see the shape differently and give you a better chance of drawing it accurately.

## You Deserve A Break

Over time your eye will get tired. While you may not notice it, your ability to see your mistakes will become compromised. This is not because you are physically tired (although you may be). It is because of the way our eyes and brains work. The longer you look at something, the more dull your perception of the object becomes. This is more the case because, as you are drawing, you are intently studying the object. How do we overcome this? Taking breaks helps a great deal. A quote from Leonardo da Vinci applies here, *"Every now and then go away, have a little relaxation, for when you come back to your work your judgment will be surer."*

## The Mirror is Your Teacher

The mirror also helps. It allows you to see the setup (both the drawing and the cast) either backwards or upside down, thereby giving you a much needed fresh eye. There are two ways to use a mirror. The most effective is to stand in your viewing position and turn to the side. Close your eye and hold the mirror up to your head. You will have to rotate the mirror back and forth but eventually you will figure out how to get a look through it at the setup. The only difficulty is that you have to make sure that you are positioned

properly. Prior to using the mirror, I usually find a horizontal measurement on the cast (like the distance between the tip of the nose and the edge of the cast) that is small enough for me to remember. Then I turn to use the mirror and immediately look for that distance. If that distance is off, I move slightly to one side or the other until the distance is the same.

The other way to use the mirror is to stand in your position (facing the setup) and hold the mirror over your eyebrows. Again, close one eye, and look up into the mirror. You will have to experiment with how much to tilt it in order to see the setup. Looking through the mirror in this way turns the scene upside down. This does work but remember that our eyes really see things upside down. Our brain just flips the image before we perceive it. So, looking at the setup backwards as in the first version, is really *fresher* than turning it upside down.

From Leonardo again, *"When you are painting you should take a flat mirror and often look at your work within it, and it will then be seen in reverse, and will appear to be by the hand of some other master, and you will be better able to judge of its faults than in any other way."*

Using the mirror

## Back and Forth
Flicking your eye back and forth is a very good way to check yourself as well. Our brain remembers what the eye sees for an instant. This is called persistence of vision. When you flick your eye back and forth from the cast to the drawing fast enough, your brain tries

to combine the two images. Whatever is different will seem to move a little. I use both the mirror and the flicking eye concept throughout the process of doing a drawing or painting. In fact, the most common way I critique a student's work is by flicking my eye back and forth.

## Follow Through

A final way to check the drawing is what I call *follow through*. All lines have specific directions. For instance, the line of the nose goes basically up and down. On the cast, run your eye down the line of the nose. When you reach the end, continue until this *line* crosses another shape or line. Where does that crossing occur? Your drawing must show the same thing.

## First Things First

Do not begin shading anything until you are confident in your block in. Once you have the basic shapes blocked in and are confident in their accuracy, you are done with the first part of the drawing. This step may take you a day, a week or a month, depending on how complicated the cast is. Do not rush it. Take breaks and use your mirror.

# Beginnings & Blocking In Summary

- Always view the cast from the viewing position. This means NEVER stand at the drawing board and sneak a peak at the cast.

- Always close one eye when looking at the cast.

- Do not go too dark with your lines.

- See the big look and simplify the shapes.

- Always recheck every measurement.

- When possible, use triangulation as this will eventually speed your drawing and help you ween yourself from the plumb line.

- Concentrate on drawing a very accurate contour or outline before drawing areas within the outline.

- Once you are sure the outline is accurate, draw in the bed-bug line.

- Find and draw the light and dark islands.

- Always compare the shapes between the cast and the drawing and between parts of the cast or drawing to other parts of the cast or drawing. Every shape is relative to others.

- Do not draw features, draw shapes that happen to look like the features you are seeing.

# Beginnings & Blocking In Summary

- Take frequent breaks.

- Check yourself often by using the mirror and by flicking your eye back and forth.

- Compare, compare and compare again.

The finished block-in (including some shape errors).
As I am left handed, I place the cast on the right and the drawing (easel) on the left. Right handed artists would generally do the opposite.

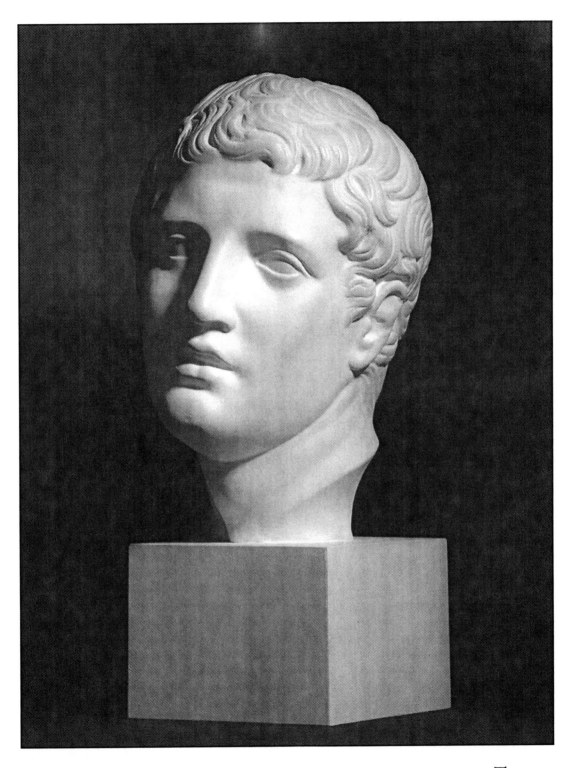

The cast.

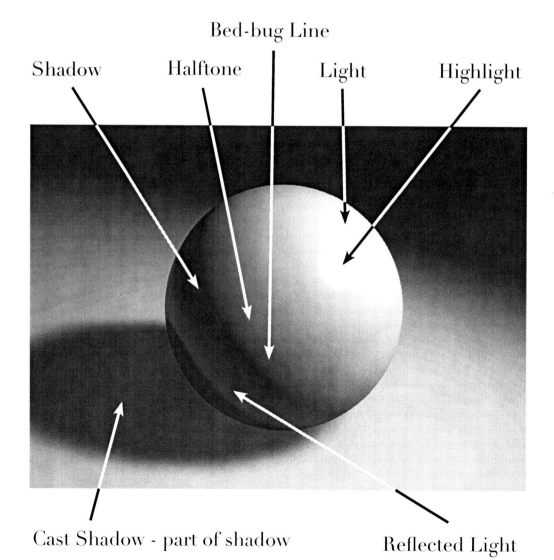

Bed-bug Line

Shadow      Halftone      Light      Highlight

Cast Shadow - part of shadow      Reflected Light

# ·Values & Shading·

*"Art is born of the observation and investigation of nature."*     -Cicero

Below, left:
The segmented, 5 value scale
Below, right:
The continuous value scale

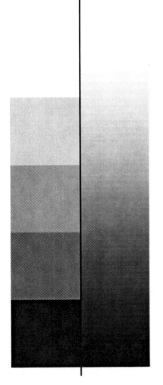

Our ability to accurately see shape is partly dependent on value. In other words, the act of shading in the cast will help you correct your shapes.

Part of the Sight-Size artist's job is to separate the lights from the darks. This again is related to the big look. The big look lacks detail and refinement but it contains all that is essential for a convincing likeness. One of the things I did when drawing the basic shape of the cast was to define the main shadow line, or bed-bug line. This line is the separation between the main light and dark and it quite often runs the length of the object. If you have not done so, take pains to draw this line as accurately as you can.

What are values? Values are the visual range from light to dark or vis versa. There is an infinite range of values so it is helpful to simplify them into 5 categories.

**Shadows** are obviously your darkest tones. The value of a shadow is determined by the natural value of the object the shadow is falling on. Hence, a shadow on a white cast will be lighter than a shadow on a black cloth. Cast shadows are shadows that are cast by an object that block the light source.

**Halftones** are values that are between shadow and light. This category is large as there are an infinite number of halftone values.

**Lights** are the areas on the cast where the light is directly hitting it. Anything darker than the light is a halftone or a shadow.

**Highlights** are brighter than the lights. A highlight is created where the surface is either shiny or has a bump or ridge.

**Reflected Lights** are not really lights at all but are light reflections within a shadowed area.

## A Narrow Range

Our materials determine how close we can get to nature's values. The darkest dark in nature is much darker than the darkest mark we can make with a very soft charcoal stick. Conversely, the white of our paper is the brightest we can achieve in the drawing. Nature can be brighter than that. What we are left with is relative. While we can try to approach nature's values, we have to be very mindful of the relationships between the values. As an example, always be thinking things like, 'this dark here is lighter than that dark but darker than this one.' Correct value relationships are more important than trying to out do your materials.

## Squint

The best way to see values is to squint. To squint, close your eyes and then just barely open them. The first thing you can see will be a mixture of lights and highlights. Everything else will be either shadows or dark halftones. Squinting visually simplifies things and helps you determine the correct values you are seeing. In a sense, when you look directly at something, your eye adjusts its sensitivity based on the values and colors it is seeing. One can perceive this happening when you go from a dark room to intense sunlight. Your eyes adjust. The same thing happens, on a minute scale, all of the time based upon what you are focussing on. Squinting mitigates that adjustment and helps you to see both the true value and its relationship the other values nearby. In jest, I have often told my students that reproducing nature was quite simple. First you have to squint way down until you can hardly make

Shading in

anything out at all. Record exactly what you are seeing like that. Then, open your eyes a bit and do the same thing. Then do it again. Keep going on like this until your eyes are fully open. Once you get there, you're done.

## No Scribbling

Shading with charcoal is very simple but it can be time consuming. Generally, you start with a very sharp stick of soft charcoal and draw lines at a 45 degree angle. Don't scribble, which is scratching back and forth. Go in one repetitive direction. Build up (or down) the value through layers rather than pressing hard to get it dark enough in one go. We have a saying, 'sneak up

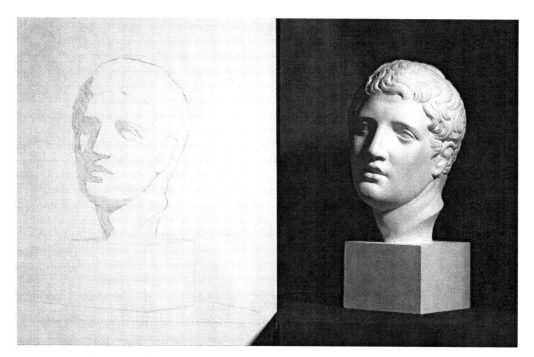

on your darks.' This means that you should not hit your darks with full strength right off the bat. Part of the reason for this is to preserve your ability to correct mistakes. A dark, dark will not erase very well. Another reason for this is that all values are related to all the other values within the scene. Until you have all of the values in, you cannot accurately see how dark (or light) you really need to make each value.

Main shadow lay in

The cast in black and white

## Darks First

I generally shade in the shadow side of the cast first. Another option would be to shade the background first. Essentially you are shading from dark to light. Either way, you want to shade your darks first so that you end

up with a highly contrasted image. Imagine being allowed to use only black and white with no mixing of the two. What would be black, and what would be white? The goal is to simplify the shapes into a flat mosaic. Yes, it is a start on recording the proper values but it also helps you correct your shapes. Find the darkest, darks first and work up to the lights. For now, avoid the reflected lights. Shade them in just as if they were shadows. Part of the final stage in the drawing is to slightly erase out the reflected lights. When one does that too soon, they usually overstate the value and make it too light. This results in an unwanted wet or sweaty appearance.

## The Background

Shading in the background does take time. Don't try to make one line go all the way across the page. Shade in small sections. Remember that you are not trying to go as dark as you can at this point, you are just laying in general, relative tones. Once the background and darks are more or less covered, go back over them with another layer. Besides darkening things a little, this layer will help you smooth out your passages a bit. You will have to do this a few times.

Laying in the background

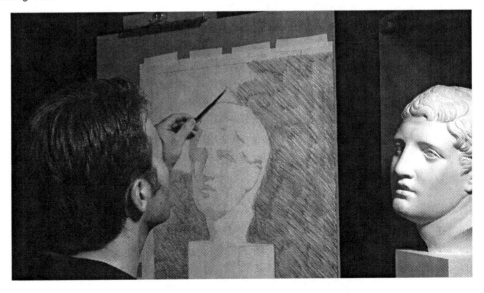

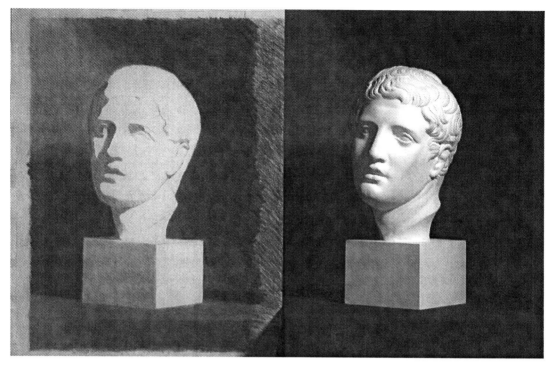

The drawing after the first round of shading

It is not always necessary to shade in the entire sheet of paper. I normally have my students square off an area around the cast that is about 4 inches beyond the perimeter. This is the border and all the shading stays within that boundary except for the side of the paper that the actual cast is next to. That side gets somewhat shaded in all the way to the edge of the paper. When seeing values it is easier to visually switch from like value to like value if there is not a white strip of paper in between.

Students often ask me about blending with paper stumps. When I was in school, we were not allowed to use them. The reasons are that you lose some control and it is very easy to mar the paper. If you just can't get a smooth surface with layers of sharp charcoal, some soft tissue paper may help. Part of the difficulty in getting the desired smoothness is the drawing paper itself. Often there will be thin, dented lines in the paper from the rack it was dried on when it was

manufactured. These are hard to cover up completely. Depending on how tight you would like your finished drawing, you may choose to ignore these or spend days covering them up.

The student will notice that a lot of the charcoal does not seem to stick to the paper. Every now and then, gently blow it off and re-shade the area. Sometimes the paper gets so much charcoal on it that it just will not seem to accept any more. When this happens, angle your shading in another direction. Another help is to move up to a sharp, medium piece of charcoal. This helps to blend the charcoal around a little and smooth things out.

Correcting an error

## Recheck Your Shapes

At this point the drawing should look like a black and white mosaic or set of puzzle pieces and the outline should be gone. We are not interested in the illusion of depth here, but a flat pattern of dark and light shapes.

Keep your values flat. Comparing it to the cast, the drawing should also be lighter over all. This is a perfect time to recheck all of your shapes. Take a break and when you come back use your mirror. Remember to close one eye. Spend a lot of time checking your shapes as the process of correcting shapes gets more involved and difficult the further along you get in the drawing. Keep your eye and attention moving, never working one area for too long. Constantly compare one shape to another, not just between the drawing and nature but between the different parts on the cast. Those same relationships need to be present in the drawing.

When you are happy with the shapes, squint down and look at the darks again. Darken in the darkest darks to the value level you think they should be. Make the drawing look like the scene when you are squinting way down.

## Halftones

Next come the halftones. Squint again (with your eye a bit more open this time) and look for the areas that are too light to be shadows but too dark to be light. Start with the darkest ones of these and shade them in. If they are prominent, I might lightly outline their shapes first so I know where the boundaries of the tone are.

Due to the fact that many values blend into each other so gently, it is sometimes hard to discern where a shadow ends and where a dark halftone begins. Since a shadow is the absence of light, it is not possible to cast another shadow upon a true shadow. For shadow edges that are hard to define, take your charcoal and place it between the light source and the edge. Run this along and try to see where, along that edge, the

Looking for the shadow edge

shadow from the charcoal stick is visible. Where you can see it, is a dark halftone and where it disappears is shadow.

For large halftone areas like the hair in this cast, I lightly shade the whole section in and then go back to darken in specific shapes. Using a kneaded eraser I draw with it to erase out the light areas.

Drawing with the eraser

Usually I can still use a very sharp, soft for the darker halftones. Quickly however, this ends up being too dark and I have to use a medium charcoal. The lighter halftones often require using the hard charcoal. One must be careful however as a

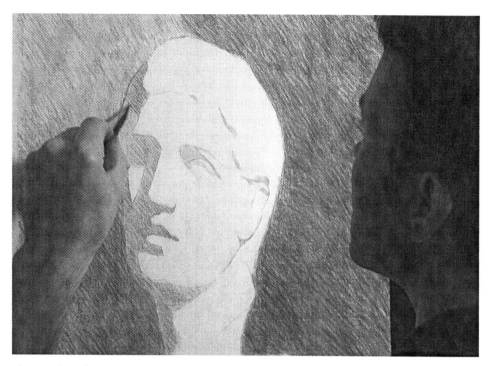

Laying in another layer of shadow

sharp, hard is dangerous. Kidding aside, it is very easy to press too hard and mar the paper. Be very gentle.

## Darkest Dark and Lightest Light

Do not over darken your halftones. This will make the drawing look muddy or wooden. We call this over-modeling. Getting the correct values for the darker halftones is done by comparing them to the darkest, dark value of the shadows. Conversely, the lighter halftones are compared to the light values of the lights. All values are relative to what surrounds them and halftone values are no exceptions to the rule. Set up a visual hierarchy of value by finding the darkest dark and the lightest light. Judge every value against those values. Think, 'darkest dark and lightest light.'

## Light

Toning the light areas of the cast would be the next step. These areas are sometimes darker than the paper but they will not be darker by much. Approach these values with care as you do not want to shade them too

dark (over-modeling). Compare them to the lighter halftones to get a sense for how dark to shade. Once again a sharp, hard will be the charcoal of choice.

## Keep Moving

A common error that many students make is to highly finish one area before the rest of the drawing is up to the same stage. It seems that we are programmed to draw that way. This is called *piecemeal seeing*. One of the problems with this is that, while the finished section might look perfect, it may be in the wrong place. Then, you will have to erase and draw it all over again. Part of naturalistic seeing is how one area relates to every other area. If you finish in sections, the resulting drawing will look just like that, sectional. We must learn to see the whole and keep the parts subordinate to it. Try your best to keep all areas of the drawing moving along at the same pace.

Laying in the hair halftone

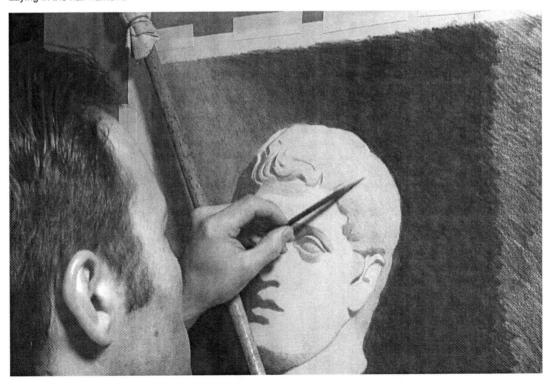

Shading in properly and getting the correct value relationships takes a lot of time. I would even say that this process is 60% of the time spent on the whole drawing. Remember that every time you shade or darken something, you risk changing the shape. That and the fact that the closer you get the values, the better you can see the shapes, means that you have to keep checking the shapes over and over again.

At this point, despite the harsh edges, the drawing should look fairly good to you. If it does not, then you either have a shape problem or a value problem. It may help to get an opinion other than your own or you might need to take a break from the cast for a few days. I know from my own work that I am rarely happy with the results until somewhere near the final session. Part of the reason for this is the quest for perfection that never seems to be truly achieved. In a way, that can actually be helpful as it forces one to constantly strive to improve. When you return, you will have a fresher eye and a better chance of judging the drawing more objectively. Even now, using your mirror, squinting, flicking your eye, all of these things are still valid in helping you to correct the drawing. Are the darks, dark enough? Are the halftones too dark (over-modeled)? Etc...

Also, spend some time trying to smooth the values that you have shaded in if they are too rough and sketchy. Be careful though as smoothing does change the value.

## A Highlight Conundrum
The student will most likely find that the highlights on the cast are brighter than the raw paper. Even the lights on the cast may appear brighter than the paper.

There is a choice to be made here. One can artificially darken some of the lights and light halftones (and maybe even some of the darks) in an effort to punch up the highlights. But, as noted earlier, overly dark lights and halftones result in over-modeling. Another option is to ignore the difference and live with the fact that nature is brighter than our materials. Trained artists often modulate how they record the things they are seeing to suit the final image, but the student's effort should be based on recording what they see relative to their materials. With my students I make the decision on a case by case basis depending on what I believe the student is capable of seeing and what the cast lighting looks like. There is no easy answer for a charcoal drawing on white paper but the job gets less difficult when using toned paper because you create the lights with white chalk. Similarly, when doing a cast painting, you create the lights with white paint. Even so, white paint is still darker than nature's highlights.

The values completed

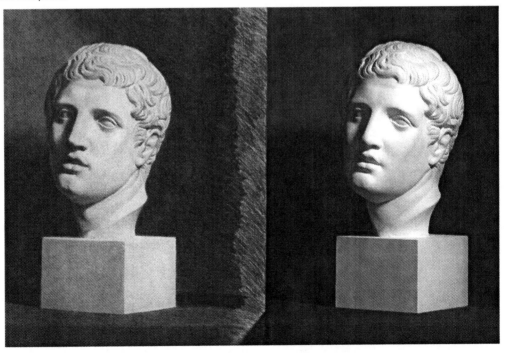

The progression is this: Darks first, then dark halftones, then halftones, then light halftones, then lights and finally reflected lights.

At this stage of the process, I generally suggest that the student keep the edges between most of the values more or less distinct. This allows them to focus on shape and value without worrying about soft and sharp edges. This also makes it easier to correct a shape because the boundaries are visible. The softer the edge, the harder it is to tell where the shape actually is.

## Looking Away

Once the student is confident that all of their values are correct, it is time to begin thinking about the reflected lights. Bear in mind that these 'lights' are most often surrounded by darks and therefore any overstating of them will draw the viewer's attention like a bulls eye. Early on and often we have been squinting at the cast. Notice that when you do that, the reflected lights generally disappear and that was good because ignoring them helped us to see the big look. Now, open up your eyes and look slightly away from the area of the reflected lights. Perceiving these lights peripherally in this way can help you to see their true value. Try not to look directly into the reflected lights but look slightly away from them. Looking away from the area in question is also a key to seeing color, but that is another book.

More than likely you will be erasing shadow to reveal the reflected light. The kneaded eraser is one of the proper tools for this. As it is though, it may erase too much. It is sometimes helpful to quickly shade in a section of another sheet of paper with a soft stick of charcoal. Then, make a point on the eraser and gently

erase some of the section you just shaded in. These actions result in a point on the eraser that is a little soiled. Therefore, it will not erase as effectively and that is perfect for erasing reflected lights. To a certain extent, a sharp, hard can also erase darker areas by scraping off some of the charcoal.

You may choose to leave out some of the more subtle reflected lights. The choice partly depends on how subtly you can erase them. All in all, carefully understate the reflected lights that you do put in (or erase out, as the case may be).

## Pulling It All Together

After the student is trained and has been painting for a while, the segregation of shape, value and edges becomes blurred. When I am painting, I am not consciously thinking in these separate stages. Often, when I shade something in I will also soften the edges as I shade. But for the student, edges are the next, distinct stage.

# Values & Shading Summary

- Always view the cast from the viewing position. This means NEVER stand at the drawing board and sneak a peak at the cast.

- Squint to see the main values.

- Start with the darks first.

- Sneak up on your darks.

- Initially, ignore the reflected lights.

- Shade in flat, uniform values.

- Keep your eye and attention moving. Do not finish one area of the drawing before everything else. Keep all areas of the drawing progressing at a similar rate.

- Set up a visual hierarchy (darkest darks and lightest lights) to compare all of the other values to.

- Beware of over-modeling the halftones and lights.

- Do not draw features, draw shapes that happen to look like the features you are seeing.

- Take frequent breaks.

- Check yourself often by using the mirror as well as by flicking your eye back and forth.

- Compare, compare, compare.

Shading in the background

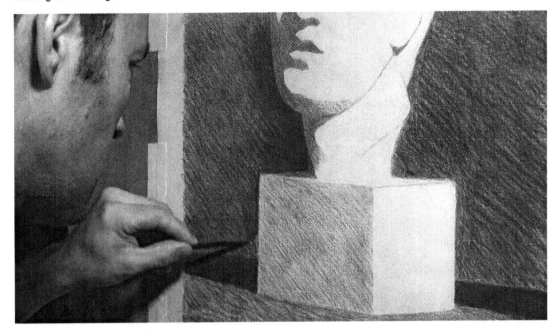

Shading in an eye

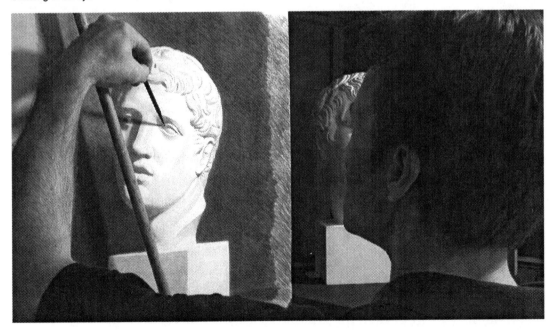

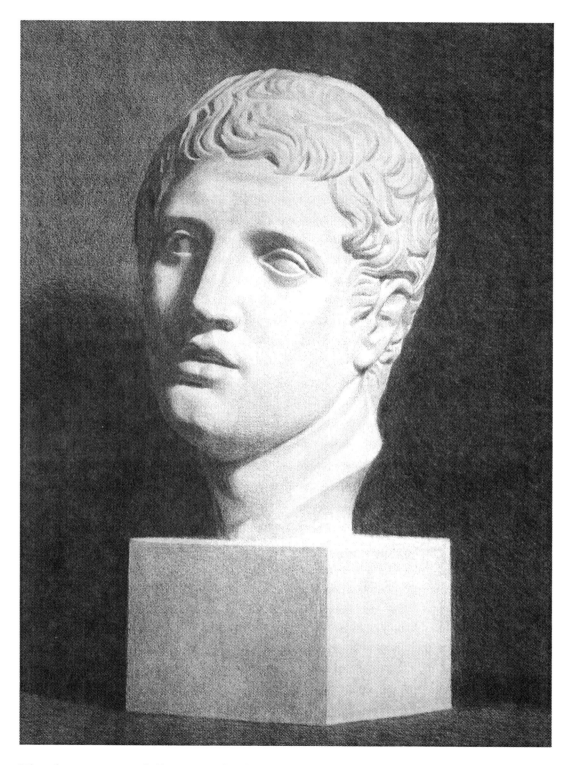

The drawing in a full range of values (still a little lighter than nature).

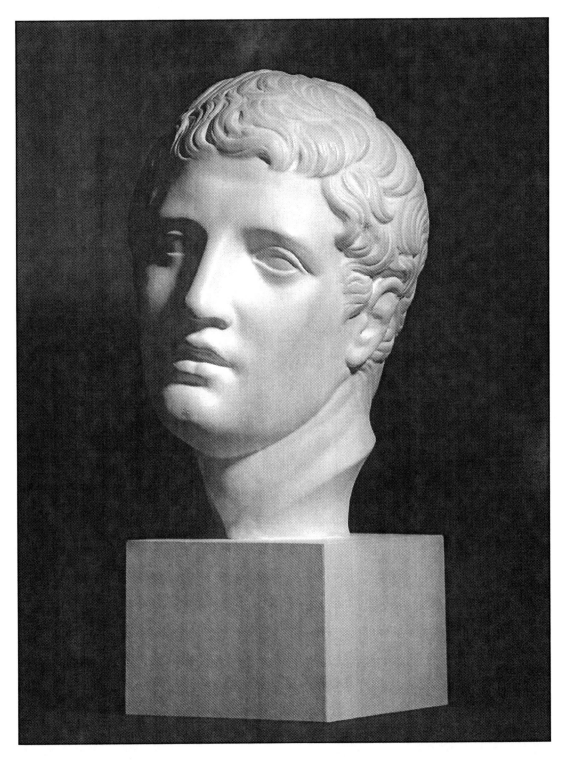

The cast.

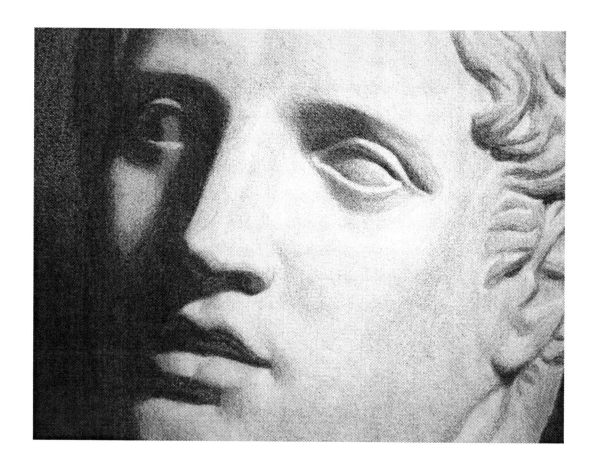

# ·Edges, Focus & Finish·

*"I don't dig beneath the surface for things that don't appear before my own eyes."*
-John Singer Sargent

For the student, the concept of soft and sharp edges is often a revelation. Left to their own devices most people would draw everything they see with uniformly hard edges, only softening when the edge in question is clearly obscure. But nature is not visually defined through hard edges alone.

*Showing a visual progression of edges in a book is difficult. Photographs (or scans) and the print process all conspire against me. Therefore, I ask that you pay more attention to the written word than the images that accompany this chapter.*

## Simply Put

To begin, the bottom line is this: stand in your viewing position and stare at one of the eyes of the cast. Sharpen the edges on the eye, just the way you see them. Then, keeping your focus on that eye, try so see peripherally. Soften all the edges you see, as seen from the focal point of the eye you are focussing on.

Rarely look directly at the areas you are trying to draw but try to keep your eye focussed on the eye of the cast. I often describe this as 'thinking' about the other areas. Does that make sense? If so, and you want to take the quote from Sargent that begins this chapter literally, feel free to skip the rest of the chapter. I hope, however, that you will read on.

## How Our Eyes Focus

Our eyes focus on a point, or more correctly, two slightly divergent points. This is what gives us the sense of depth. The focal point of the eye (the area of sharpness) is roughly 2 to 4 degrees in diameter. Moving away from that point of focus, things get progressively more and more out of focus. This happens not only laterally and vertically but also front to back and in every direction.

It is rare for our eyes, or minds, to fixate on a specific point for very long. Our eyes are constantly moving

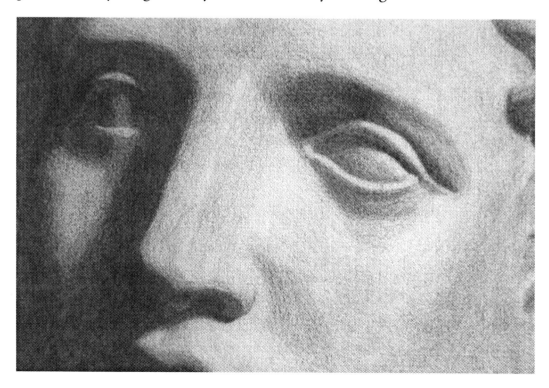

and refocusing. Much of this is subconscious and is related to the fact that our bodies are in constant motion. The simple act of breathing moves our head (and therefore our eyes). People rarely sit still. As our eyes dart around, they continually refocus and sharpen each new thing that is central to our vision.

## The Eye is Not a Camera

Many have compared the eye to a camera lens. In some specifics the comparisons are valid. But when it comes to focus, the comparisons get blurry. As noted before, the eye focusses on a point. The camera focusses, more or less, on a plane. This is a bit overly simplistic and those optometrists among us will note the discrepancies. My point however is this, the camera's area of sharpness is much larger than the eye's. Most photographs are sharply focussed in ways that our eyes cannot duplicate.

In today's society we are saturated with photographic images. Television, movies, magazines, photos and computers have all conspired to deaden our vision. For many contemporary artists the highest compliment is, 'that looks just like a photograph.' Since many artists use photographs as their source material, the compliment may be valid. But as mentioned above, the eye is not a camera. And, nature is not a photograph. The difference is important.

Properly painted, a painting can convey a sense of depth and a presence that a photographer can only dream of capturing. This is less so for a drawing but it is still relevant.

## Consistent Distance, Persistent Focus

As mentioned earlier, the importance of the artist's viewing position cannot be overstated. This viewing position can determine how the edges are handled and will give the artist some control over the viewer. The drawing as a whole would also come into focus at the same distance it was drawn from. A single, distant viewing position is at the heart of naturalistic seeing and this is what Sight-Size excels at.

Along with viewing distance, a persistent focus can also direct the viewer by showing them what to look at first, then second and so on. If the artist were to focus on one area of the cast and accurately reproduce all the edges seen in relation to that area, the viewer would automatically and subconsciously look at that part of the drawing first. This phenomenon implies that the artist has to *see*, or perceive areas of the cast where the artist is not focussing at the moment.

Viewing position and focus help the viewer see the work as a whole, rather than piecemeal. Every aspect relates to every other aspect in the painting or drawing. This is called a unity of focus and is very important for naturalistic seeing.

## Velazquez

A discussion of edges would not be complete without mentioning Velazquez. For many painters, especially those interested in naturalistic seeing, Velazquez is king. He has been called, 'the painter's painter' and

few artists, prior or since, have matched the optical qualities of his best work. When it comes to edges and a sense of the real, it is hard to out-paint Velazquez.

Velazquez's artistic life, like many artist's, is generally separated into periods. Once such period began around 1628 when the most famous artist of the time, Flemish artist Peter Paul Rubens, visited the Spanish court of Philip IV. Velazquez was court painter by that time and unquestionably had many discussions with Rubens. It is said that Rubens' influence caused the king to grant Velazquez permission to travel to Italy in 1629.

Whether it was his contact with Rubens, his sojourn to Italy or both, we will never know, but from that time forward Velazquez's technique changed. Gone was the hard edged, Caravaggio influence of his contemporaries. Muddy shadows were replaced with an airy luminosity. His paintings seemed to take on a life, or presence that was quite uncommon for other paintings of the time.

To the uninitiated, Velazquez's paintings from this period forward have a somewhat blurry, unfinished quality when viewed in a book. Seen in person and from the proper viewing position however, the paintings seem to breathe life. This effect is rarely seen in photographs of his paintings so I will not present them here. Again, one must view them in person and from a distance to see this effect properly.

On one of my trips to Madrid in the 1990's, I and a few of my students set out to record the optimum viewing position of the Prado museum's Velazquez paintings. The galleries in the Prado are generally large

and well lit, which is perfect for standing back from the paintings.

The routine was this, we began by standing a few feet back from the painting. Then, slowly, we backed up until the painting as a whole came into focus. We noted that distance and proceeded to back up again until the painting lost it's focus.

Many of the paintings did not come into focus until 12 feet back, including his smaller paintings of dwarfs. For his larger works, like *The Fable of Arachne,* it took nearly 30 feet to find the focus.

My professional opinion is that Velazquez figured out Sight-Size. Notice that I did not say *discovered.* Nor do I mean to imply that he was the only one to paint this way. The evidence is simple but one needs access to the paintings to see it. The paintings are not uniformly in focus at the found viewing position.

The focus generally centers on whatever the center of interest is in the painting and gradually gets more and more out of focus as you move away from that focal point. But even that progression is not always uniform as would be the case when the artist blurs an edge just because it is not near the center of interest. Velazquez directs the viewer's eye, from place to place as he and his eye literally saw fit. I do not believe that one can successfully do that without doing the painting from a distance and comparing the painting directly with nature as in Sight-Size.

Is this concrete evidence for the use of Sight-Size by Velazquez? No, but we do know that many 19th century artists believed so. I would again direct the reader to Nick Beer's essay on the subject for the complete written story of the history of Sight-Size. See www.Sight-Size.com for Nick's essay.

## 'Turn Your Edges'

Shape and value do have a role in giving the viewer a sense of depth in the drawing, but how the edges are handled is what makes the drawing stand out.

'Turn your edges' is a common saying in ateliers and the implication is valid. Edges are *turned* from sharp to soft. This is what makes the drawing appear to have depth. Hard edge drawings usually look flat.

All along I have been advising the student to keep the separation of values fairly distinct. This was to help the student see and draw accurate shapes. As an aside, were the student doing a painting, I would be advising that the student blur their edges throughout the majority of the process of the painting. As a final step (or steps) the edges of the painting would then

be selectively sharpened based upon observation. This is due to the properties of paint and the difficulties involved in softening a dry edge. With a drawing however, the beginning student generally softens near the end of the process.

Turning an edge

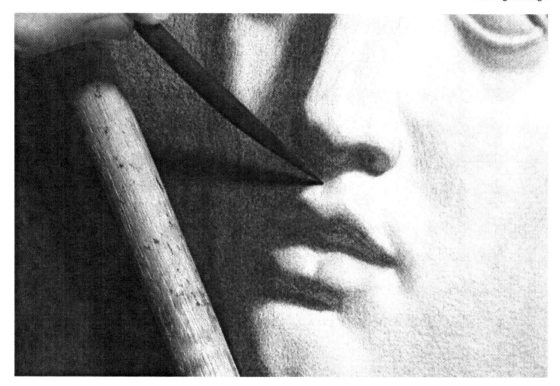

## Kinds of Edges

Edges are not only visual. There are also tactile edges. The edge of this book both looks and feels sharp. The edge of the base of the demonstration cast also looks and feels sharp. But the concept is not uniform. All visual edges are not tactile. The perception of sharp and soft edges is affected by a number of things. Is the edge of what we are looking at physically sharp (tactile) or soft? That physical aspect can supersede many of the visual things that focus and value might do to our perception of the edge. Contrast can also affect our perception of sharpness. Highly contrasted edges often seem sharper than low contrasted ones. In

addition, both focus and distance have major parts to play in edge distinction.

Turning an edge

## Edge Falloff

Edges created through light and shade (non-tactile edges) are also not consistently sharp or soft. Imagine a sunny day and a tall flag pole casting a shadow on the ground. The farther away the shadow gets from the pole, the softer the edges of the shadow will be. If the pole is tall enough or the sun is low enough, these edges near the end of the shadow may be so soft that they are impossible to define. This effect is called edge falloff and can be seen in many edges.

## Edges With Purpose or Accidental

The act of shading in an area creates an edge on the border of the shading. But this edge is unintentional. Often, an unintentional edge is sloppy. When you need a sharp edge, create it intentionally. When you need to soften an edge, be careful to do it intentionally.

## Sharpest Sharp and Softest Soft

Much like the progression of values, edges have their hierarchy. In the chapter on values, I presented the idea of 'darkest dark and lightest light.' With edges we say, 'sharpest sharp and softest soft.'

Stand back in your viewing position and close one eye. What is the sharpest sharp and the softest soft? These are your parameters. Compare all the edges you are trying to draw to those. In a drawing I find it helpful to begin with the sharps first (in a painting I do the opposite). Once you find the sharpest edge, use a sharp, medium or hard piece of charcoal and carefully clean the edge up. Use your kneaded erasure if you add too much. As sharp as you may think the real edge is, it is most likely softer than you are drawing it. Few visual edges are as sharp as we can draw. Use your sharp, medium or hard charcoal and soften the edge a little. Remember that the edge is not a line, it is a transition from dark to light. For a sharp edge, this transition is abrupt.

The softest soft may indeed be so soft that you can't find the edge. These soft edge transitions often take place over a longer span than sharper edges do. The smoother you can render these areas, the more real the drawing will appear. Look for all areas on the cast that have transitions this soft and blend them in. Again, use a sharp stick of charcoal at whatever hardness suits the value. Also, be aware that to soften an edge requires changing the value of the edge. Make sure that the transitions you are drawing are accurate in value.

Next, run your eye along the cast looking for the softest actual edge you can see. This will be your softest soft. Soften this edge carefully.

Once you have found your edge extremes, look for the sharps that are a little softer than the sharpest one. There may be many of these. Just make sure that they are, in fact, identical to each other in sharpness. Continue to work your way around the cast from sharp to soft until you feel that you have rendered all of the edges correctly. While this stage may not take as long as shading in the values, do not rush it. Properly realized edges are some of the things that separate the competent cast drawing from the masterful one.

## Finding Focus

Usually we look at a person's eyes first. The question then becomes, which eye to look at. Sometimes this decision is made for you due to the orientation of the cast and/or the lighting. If the primary eye is not obvious, I usually choose the eye that is on the far side of the face. That way the viewer has to visually travel across the face to get to the eye. Regardless, pick on eye to focus on. If your cast is not of a head, you will have to decide what you want to have the viewer look at first. Often, this center of interest is a highly contrasted area.

## Start Staring and Look Away

Generally speaking, our eyes seem to sharpen up whatever we are focussing on. In other words, when you look straight at an edge, it will seem sharper than it will if you look away from it.

Remember my direction in the beginning of this chapter where I suggested that you focus on an eye and merely *think* about the other areas of the cast when drawing them rather than look at them directly? When first trying this type of seeing it is hard to *think* about areas much farther away from the focal point than about

3 inches. Over time (and doing more drawings or paintings) that distance increases. When the physical distance increases, as in standing back farther than your viewing position, the diameter of your *thinking perception* also increases. In my experience it takes a while for a student to get good at this sort of seeing.

## Eye Can See Clearly Now

Look at the eye you chose for the center of interest on the cast by staring at that spot from back in your viewing position. Without focussing elsewhere, try to judge what edges in the cast look sharp. Now look at the corresponding place on your drawing and do the same thing. Do they match? Make any correction necessary and do the same for all edges on the cast. This step is one of the final, unifying acts that many non-Sight-Size artists are not even aware of.

## Accents

Accents are very dark darks, very light lights and very sharp sharps. They often help give an extra sense of depth or punch to the drawing. Yes, they are the extremes that you most likely already have in, but go over the image again to make sure you have not lost anything while modeling.

## Defying Nature

The student's job is to faithfully reproduce what is seen. Once that is achieved, deviating from nature can be a good thing if it helps the drawing or painting. As mentioned before, how you handle the edges and accents can show the viewer in what progression they ought to look around the painting. As an example, if the nose doesn't look like it is projecting forward enough, perhaps the edge should be sharper or the shadow should be darker. This is an example of the

difference between merely copying nature and creating great art.

Look at the drawing away from the cast. Does it seem to have depth? OK, but does it have enough depth? Mentally record anything that seems too flat and compare those places with the cast. If you find any difference, correct the drawing.

## Is It Finished?

As a student at an atelier, the drawing is finished when the teacher says it is. That is part of why you are paying them. Self study students however have to rely on their own intuition or their faith in an unbiased opinion. Essentially, when you can find nothing more to do to make the drawing look like the cast, it's done. Congratulate yourself, spray fix the drawing, frame it and set up another one.

# Edges, Focus & Finish Summary

- Always view the cast from the viewing position. This means NEVER stand at the drawing board and sneak a peak at the cast.

- Set up a visual hierarchy (sharpest sharp and softest soft) to compare all of the other edges to.

- Take breaks.

- Check yourself often by using the mirror as well as by flicking your eye back and forth.

- Compare, compare, compare.

-Look at the drawing without the cast to see how successful you are at suggesting depth.

- Once you are confident in your edges, find a focus point and perceive the edges in relation to that focus point without looking away from it.

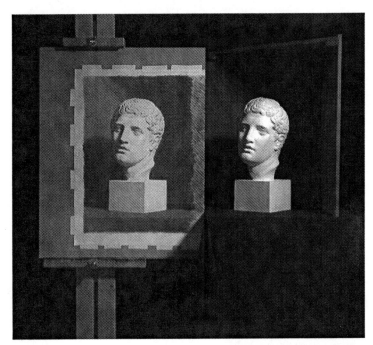

The finished drawing with cast

*"The student's first aim is to learn to see and represent nature's facts, to distinguish justly between relations. It is the training of the eye and the judgement. Imitation is not the highest art; but the highest art requires the ability to imitate as a mere power of representation... To bring out the beauty which may lie in the fact is the aim of the artist. To acquire the ability to do this is the aim of the student."*

-Daniel B. Parkhurst - *The Painter in Oil*

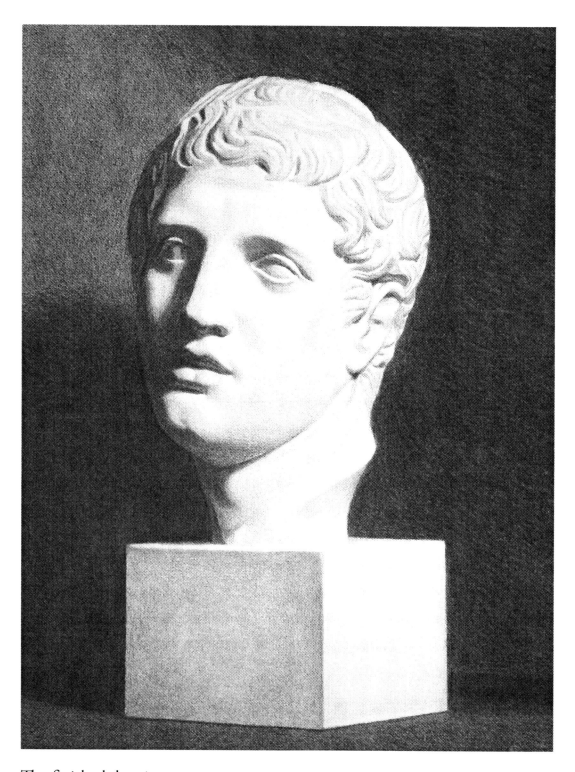

The finished drawing.

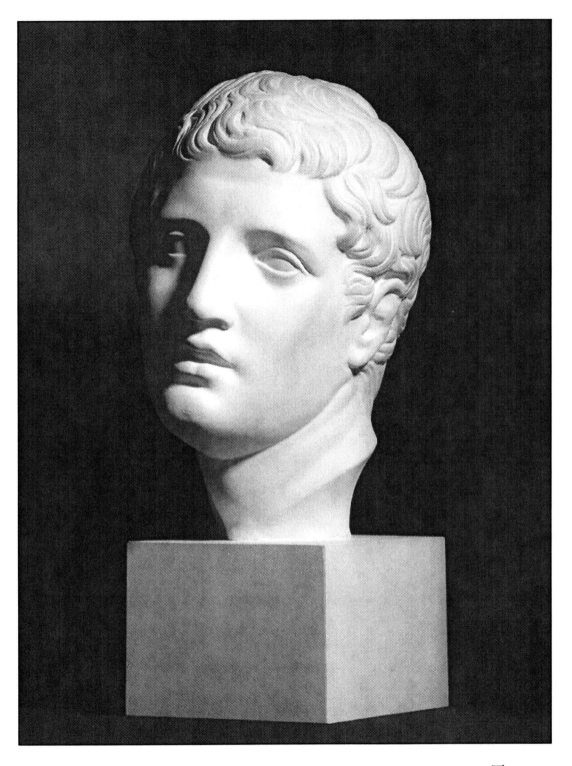

The cast.

# ·To The Student·

*"Take the attitude of a student, never be too big to ask questions, never know too much to learn something new."*
                                                                    -Og Mandino

Unfortunately, many American students are hindered in finding a suitable teacher. This is because the great wealth of old master paintings is ensconced in Europe and the US east coast. One might ask why that would matter. It matters because a teacher claiming to teach old master methods needs to have studied the Old Masters. It is impossible to do that from books (including this one) and very hard to do when the local museum has only a few paintings of note.

For those not in a big city this sounds discouraging. Take heart however as there are levels to be reached without viewing the Mona Lisa in person (it's under glass and hard to see anyway). At some point though, the student (and the teacher) needs to actually see the things that they are talking about.

When searching out an atelier or teacher, compare what they say to what they do. If they claim to teach

the *methods of the masters*, then the proof should be in their work as well as in the work of their students.

Also bear in mind that as a student you currently know very little. You will need some level of faith and a healthy benefit of the doubt.

In the end, your training is your responsibility.

For more information about other books in the Sight-Size Library™ as well as instructional DVD's and Sight-Size in general please direct your web browser to www.Sight-Size.com.

# ·To The Teacher·

*"It must be remembered that the purpose of education is not to fill the minds of students with facts... it is to teach them to think, if that is possible, and always to think for themselves."*
                                                                    -Robert Hutchins

It is no secret that teachers have a great responsibility. Teaching a personal opinion as fact or ignorantly passing on errant information can ripple through the ages. Before you decide to teach, be absolutely certain that you know what you are talking about.

Current ateliers often have student teaching assistants. If you are one, remember the obvious, you are not the master. Much can be learned from an advanced student but much is to be learned through years of experience that you do not yet possess.

If you are just out of school and have opened your own atelier or are teaching the occasional student, stick to the basics and do not try to found your own movement. Be honest with your students (and yourself) about what you know and are presenting.

The future is yours to mold.

# ·Afterword·

*"The eye of the master will do more work than both his hands."*

-Ben Franklin

The few contemporary writings that mention Sight-Size generally claim that it is a measuring system. Even books that are focussed on atelier methods give scant mention of Sight-Size beyond the traditional act of determining lengths. But the proper definition of Sight-Size must use the broadest definition of measuring. Measuring not only means ascertaining the length or width of something, it also means comparing the look or impression. It must be remembered that while many students rarely get past the literal, length and width measuring aspect of Sight-Size, a fully trained artist who uses Sight-Size might never use a plumb line or even consciously think about measuring in the normal sense. He or she will strive toward achieving the same retinal impression in the painting as is seen in nature. This impression is much easier to see and compare when the painting and nature are visually the same size as is the case when following the Sight-Size approach.

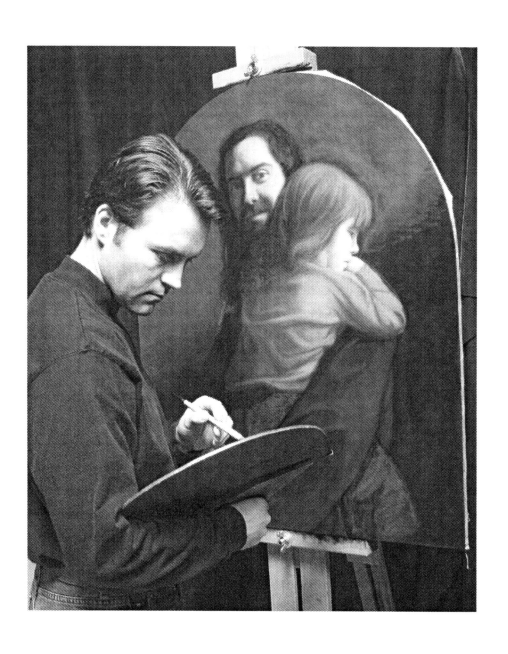

# ·About The Artist /Author·

Like most artists I have always been interested in drawing. When I was 12 years old I saw a book on the Flemish Baroque artist named Rubens. That book, in addition to my Christian upbringing, directed my life. Fortunately my family lived in Minneapolis as this area has a great tradition of teaching realist painting thanks to Richard F. Lack who started an art school there back in the 1970's. I began studying traditional oil painting methods when I was 16 years old with Mr. Lack at his school, Atelier Lack. After two years with him I transferred to Atelier LeSueur (a sister school run by a former Lack student) and studied there for four more years. In addition, I continued taking multiple evening classes back at Atelier Lack. Upon graduating from Atelier LeSueur in 1988 I then spent three months on a grand tour of the art museums of western Europe.

Completely taken with the art I was now seeing in person for the first time, I decided to move to Florence,

Italy and study with Charles H. Cecil and Daniel Graves at their school, Studio Cecil-Graves. I spent 9 months in formal training, studying both portraiture and figure painting. I learned how to grind my own pigments and prepare my own canvases, practices I still follow. In general I absorbed the art that surrounded me from the sublime beauty of the small door knocker outside my apartment to the grandeur of the Duomo, the main cathedral of Florence.

I returned to the States in 1990 after a few months in London, England. I then spent three years in Florida where I was commissioned to paint seven 8 by 10 foot paintings of the life of Christ for a church in Sarasota. The first, *Emmanuel - God With Us* was unveiled in 1993. Unfortunately, due to funding difficulties, the project ended before the second painting was to commence. I moved back to Minnesota in 1994 and while there I taught at Atelier LeSueur and at a newly opened school in Burnsville called The Minnesota River School of Fine Art.

Since I had dedicated my life to painting Christian art, I thought it would be wise to see and paint in Israel. I moved to Jerusalem in the Spring of 1995 and had three wonderful months of incredible landscape painting.

After Israel I led my first art tour of Florence and Rome. While bringing my students through Florence my former teacher, Charles Cecil, offered me a teaching position at his school. I spent a year and a half teaching Sight-Size portrait and figurative painting for Charles.

By 1997 I had again returned to Minneapolis. And, once again I was teaching at The Minnesota River

School of Fine Art. I also became the vice president of the school.

I paint the occasional portrait and landscape painting but generally I focus on religious art with Christian themes. All of the paintings I do are painted from life using Sight-Size, on hand primed canvases, using hand ground paints.

When not painting, I teach art and art history at Providence Academy in Plymouth, Minnesota.

For examples of my work, please see:
www.studiorousar.com

# ·A Course Of Study·

Part of the benefit of atelier training is the separation of skills. As an example, this separation prevents the student from being thrown into the arena of color before form is mastered. On the whole I do not believe this is very different from other, non-atelier art schools. One of the differences however is the amount of time required for each step before the student is allowed to progress. Time in an atelier is not strictly marked by the school calendar. The student only progresses when the current skill is mastered and not just because the semester or school year ends.

Throughout this book I have frequently mentioned atelier training. Rather than continue to assume the reader knows what that means, I will define it here.

During 18th and 19th century France, an art atelier generally consisted of a group of students studying under a respected artist who would come in and critique their work. The master's involvement varied

depending on the atelier. Often, atelier training was either preparation for or a supplement to study in the state run art school, the Ecole des Beaux-Arts. Many Americans and British gained access to French art training through these ateliers.

One such American was R. H. Ives Gammell of Rhode Island. While there were others, such as Simi in Italy, in America it is primarily through Gammell that the atelier tradition (as well as Sight-Size) was handed down. Gammell passed away in 1981 and though he wrote many books, none presented a complete version of his teaching methods.

Of my own teachers, two had direct connections to Gammell, Richard Lack and Charles H. Cecil. Both of these individuals ran their own ateliers (Charles still does) and the outline that follows was the generally accepted atelier course of study as practiced by their schools. For simplicity sake I am breaking the training into year long segments but the reader should know that it is not always born out by the actual training given at an atelier.

## Cast Drawing

Beginning students usually began with cast drawing.* This would be done for a half a day, each day. Finish was determined by the teacher and often the first, finished cast was merely blocked in. The number of finished casts completed was subjective and based upon the demonstrated skill of the student. The student learned shape, value and edge as well as the basics of Sight-Size through cast drawing. Progression to the next stage was usually made during the following year.

*Nowadays, some ateliers start their beginning students with copies from the flat. Near the end of this appendix I have comments on that practice.

## Cast Painting

The next stage in the training was cast painting. This often began by doing a charcoal drawing on toned paper, heightening the lights with white chalk. This drawing was then transferred to a canvas and the painting begun. These paintings were usually done with black and white oil paint but some allowed the addition of a little raw umber to warm up the black. Later, others allowed yellow ochre and an earth red to slowly bring the student into color.* As with cast drawing, the number of finished cast paintings varied. This activity was also done everyday for a half a day and it was common to spend a year doing cast paintings.

*My final cast painting was done in full color as I wanted to explore the various colors I was seeing on the white cast.

## Still Life Painting

Still life painting was the next step. Currently, a few ateliers do not teach this but it was taught when I was studying and is still quite normal. The idea was, and is, to learn to see color. Many feel this is best done from objects that do not move, as in a still life. Natural light was most commonly used for still life work, whether or not artificial light was used for the cast drawings and paintings. As with cast work, it was common to spend a year on still life painting.

## Portrait Painting

For many ateliers, portrait painting was one of the main end goals for the student. Some had their students begin portrait work with portrait drawing, whereas others moved straight into portrait painting. Some even required a portrait in black and white before allowing a full color portrait. The student usually began with a bust length portrait and eventually graduated into full size, figure length.

## From the Nude

From the start, the student would spend the other half of their days doing figure work from the nude. Beginning students would either do this in pencil or charcoal. More advanced students might paint the figure in grisaille (monochromatic painting in shades of black and white) and then in full color. For many, this full color nude and portraiture made up the fourth or fifth year.

## Advanced Work

Some ateliers offered an additional year for more advanced work. Others integrated some of the following into their normal curriculum.

-Interiors

Interiors are paintings of indoor scenes, much like many of Vermeer's paintings. The idea was to learn composition by combining still life with a form of portraiture and figure work.

-Landscape

Landscape painting was usually taught in a shortened workshop format rather than as a normal part of the atelier curriculum.

*-All competent painters should have some landscape practice but those who intend to specialize in it will need to spend considerable time and effort outside, painting on their own.*

-Multi-figure imaginative painting

Hard to define, this type of work can be anything from history, to allegory, to religious painting. Traditionally considered the highest form of painting, these subjects demand mastery of all of the other genres.

## Copying From the Flat

Centuries ago the most common way for a student to learn to draw was by copying drawings from their

master's collection. Students learned many things through this method, from technique, to composition and taste. The practice reached its highest form in 1860's France with the publication of the *Cours de Dessin* by Charles Bargue and Jean-Léon Gérôme. The drawings in the book were done specifically for the student to copy from.

In 2003, Gerald Ackerman published an English version of Bargue's book entitled *Charles Bargue with the collaboration of Jean-Léon Gérôme: Drawing Course.* Although fairly new, this book is now quite hard to find. As I write this, the latest price for a used copy on Amazon is $650. A new one is listed for $1450! Perhaps there will be a reprinting soon.

I am not about to discourage the practice of drawing from the flat. As a teenager in 1980, I did my share of flat copies to be sure. But once I made it into atelier, all we did was cast drawing from the round. Yes, some ateliers do start their beginning students by copying from the flat and when I teach pre and early teens I do the same. But my late teen and adult students always begin with full casts.

## What About Self Study Students?

Clearly, the best way to learn to draw is through an atelier or under a master. However, atelier training is not a guarantee of success nor is self study a guarantee for failure.

If you are on your own, don't fret. This book will help and you should also have a mirror by now. Read the books listed in the back of this one and look for workshops that you can attend.

# ·Ateliers·

B elow is a list of four ateliers that I have first hand knowledge about, either because I have taught there or because I know the directors. These ateliers teach their students the Sight-Size approach to drawing and painting. The list is not exhaustive and it is in alphabetical order. A more thorough list can be found at www.artrenewal.org

**The Atelier** (www.theatelier.org)
1681 East Hennepin Avenue
Minneapolis, Minnesota USA 55414
Contact: Dale Redpath or Cyd Wicker
Phone: 612-362-8421          e-mail: mail@theatelier.org

**Charles Cecil Studios** (www.charlescecilstudios.com)
Borgo San Frediano, 68
50124 Florence, Italy
Contact: Charles Cecil
Phone:  +39 055 285102          e-mail: info@charlescecilstudios.com

**The Florence Academy Of Art**
(www.florenceacademyofart.com)
Via delle Casine 21/r
50122 Florence, Italy
Contact: Daniel Graves
Phone: +39 055 245444          e-mail: info@florenceacademyofart.com

**The Sarum Studio** (www.sarumstudio.com)
Salisbury, Wiltshire England
Contact: Nicholas Beer
Phone:  0779 313 9563          e-mail: nicholasbeer@hotmail.com

# ·Suppliers·

**USA**

### General Art Materials

*Utrecht*　　　　-www.utrecht.com

Utrecht has an excellent selection of linen canvas as well as almost everything on the supply list in this book.

*Mister Art*　　-www.misterart.com

Mister Art carries Fusain Nitram charcoal.

### Plaster Casts

*Orlandi*　　　-www.orlandicollections.com

Orlandi casts are low to moderately priced.

*Giust*　　　　-www.giustgallery.com

The demonstration cast was from Giust. If you have the means, I highly recommend them.

**UK**

### General Art Materials

*The Compleat Artist*　　-www.artmail.co.uk

They carry Fusain Nitram charcoal in the UK.

*L. Cornelissen*　　　　-www.cornelissen.com

A good selection of pigments and brushes.

Italy

### General Art Materials

*Zecchi*　　　-www.zecchi.com

The staff is wonderful and they carry or can acquire almost anything art related. When possible, I buy from Zecchi, even from the States.

# ·Glossary·

Most of the art specific words used in the text have been defined within their contexts. Presented here is a select group that I feel need proper definitions from a Sight-Size viewpoint.

*Arabesque*　　　　The outline or contour.

*Bed-bug line*　　　The boundary separating light and shade. Many refer to this as the shadow line.

*Big look*　　　　Seeing whatever is being drawn or painted as a whole, unified image. Each part of what is seen is compared with every other part.

*Naturalistic seeing*　Hard to define, naturalistic seeing is a combination of the big look and a persistent focus.

*Persistent focus*　　The act of perceiving areas of the scene away from your focal point. Akin to peripheral vision.

*Piecemeal seeing*　　The opposite of the big look. This type of seeing considers everything by itself, unrelated to the whole of the image.

*Triangulation*　　　Finding a third point by defining the intersection of the angles from two, known points.

*van Dyck Z*　　　The shape formed by the eyebrow, ridge of the nose and base of the nose.

# ·Bibliography·

## Drawing
*The Practice and Science of Drawing*      Harold Speed
  Not a Sight-Size book but a solid book on drawing.

*The Practice of Oil Painting and the Drawing Associated With It*
  Solomon J. Solomon
  Largely a book on painting, it also has a good section on drawing.

## Miscellaneous Drawing
*Perspective for Artists*    Rex V. Cole
*The Artistic Anatomy of Trees*  Rex V. Cole

## Anatomy
*Artistic Anatomy*    Dr. Paul Richer
  The standard book on anatomy for artists.

## Sculpture
*Sculpting From Life - A Studio Manual of the Sight-Size Method*
  Jason Arkles
  The only book of its kind. Highly recommended.

## Web Based Resources
www.sight-size.com  All things Sight-Size related.
www.artrenewal.org  The largest on-line museum.

# ·Index·

Breinigsville, PA USA
02 December 2009

228473BV00003B/6/A